Squiggling Thru COVID-19:
How this Artist Kept from Going Nuts during the Pandemic!

Brenda Fettig Murphy

Published by
Kindle Direct Publishing
2020

Prints of the drawings are for sale.
For information, see: www.Etsy/Brendart,
or email: orderprints@brendamurphyart.com.

This book is dedicated to Margot and Claire,
two creative young ladies, who are the light of my life.

Special thanks to my husband, Jeff, for his ideas, support,
and funny observations in the process of putting this book together.

In March 2020, the COVID-19 virus came to the world, and even to Kalamazoo.
We were all told to "stay at home". I wasn't supposed to go outside at all.
Yikes! What could I do? How long will this last?

After a few days I got pretty bored watching Netflix,
Acorn TV, CNN, and Mika and Joe ranting.

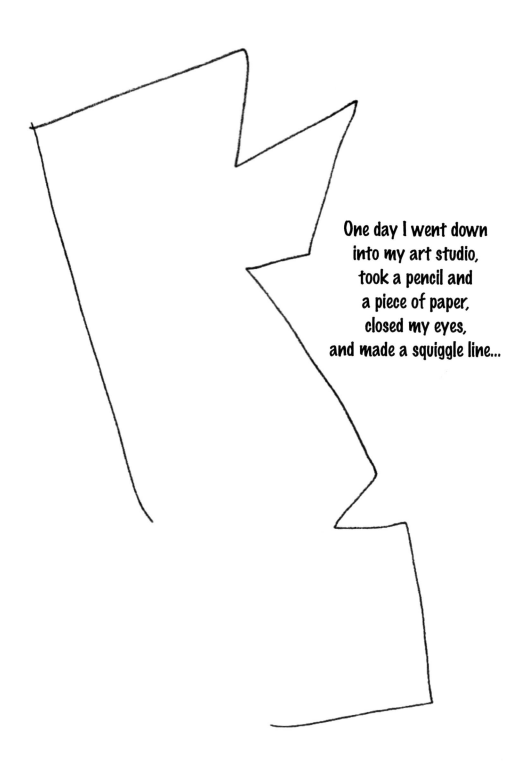

One day I went down
into my art studio,
took a pencil and
a piece of paper,
closed my eyes,
and made a squiggle line...

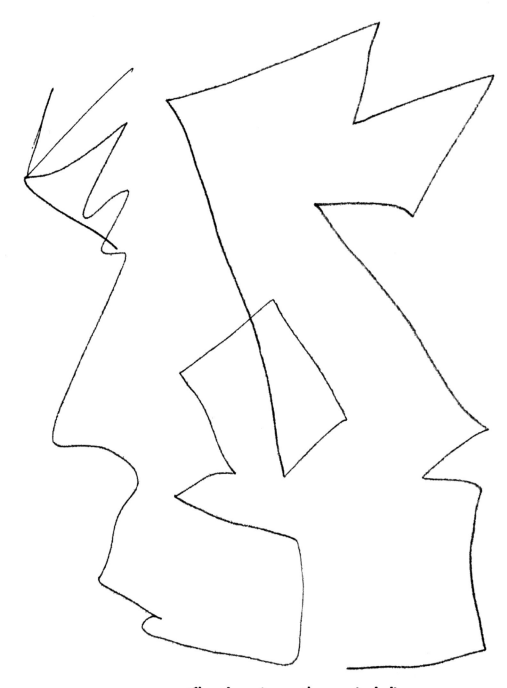

Then I made another squiggle line,
and another, and another...I opened my eyes,
and suddenly, it took shape!

I took ink pens and brightly colored markers and made the
squiggle into "something" – maybe two faces?

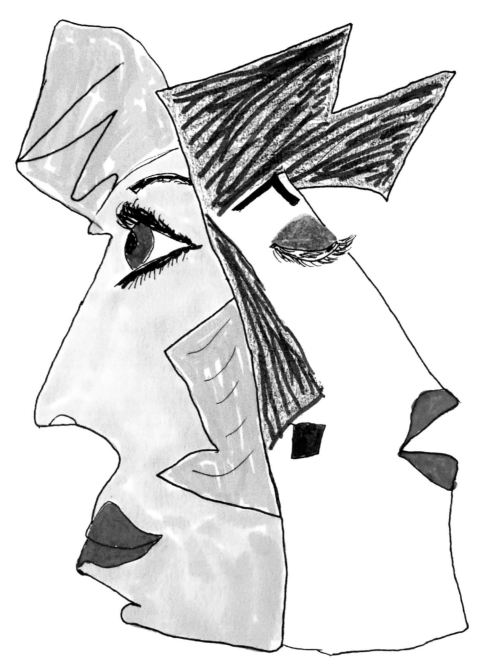

I thought, "Face-off", or,
"You're so two-faced!"

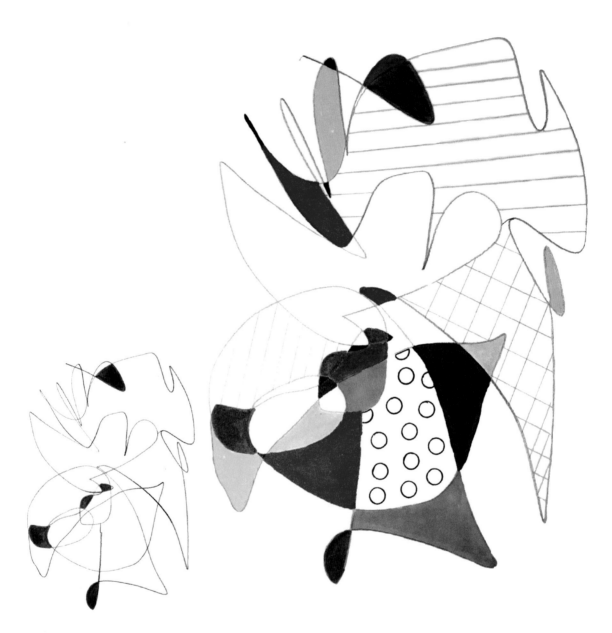

So, after a few days of drawing the squiggles like the ones you see here,
I decided to post one on Facebook and Instagram. Then
I posted a few more. I asked my friends to tell me what they
saw in my squiggle drawings, what they thought they looked
like, or to give me some "titles" for them.
And boy, did they ever!

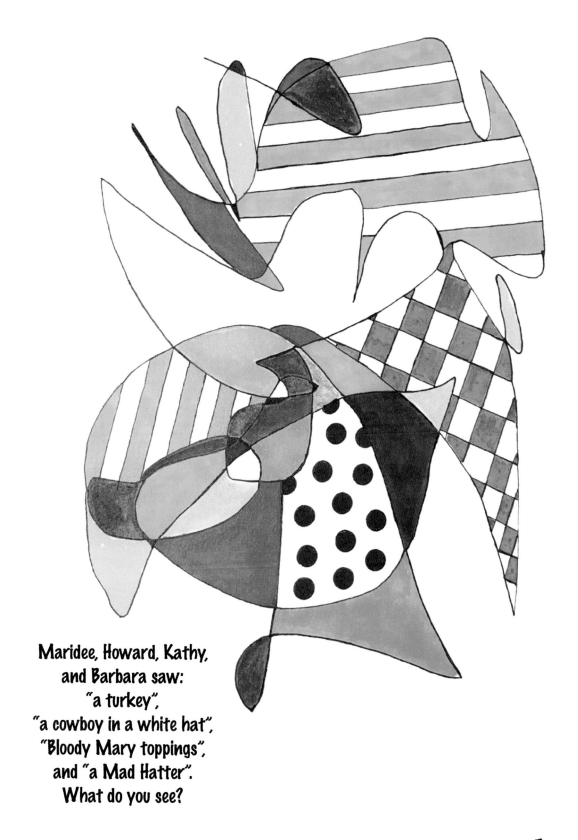

Maridee, Howard, Kathy,
and Barbara saw:
"a turkey",
"a cowboy in a white hat",
"Bloody Mary toppings",
and "a Mad Hatter".
What do you see?

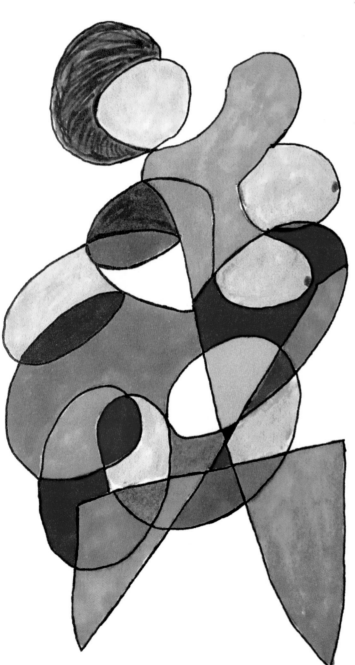

Alan looked at this and posted,
"Twinkle Toes, a plus-sized ballerina".
Perhaps she ate too much
comfort food staying at home
during the pandemic!

Well, we know comfort food
tastes so good when we're totally
stressed out – and these days,
we certainly are.

Anyway, here she is –
twirling away in her
orange pointe shoes!

Can you believe it? I drew this squiggle with
the pencil in my right foot – well, between
the toes of my right foot. It was great fun!

What do you see?
What does it look like?

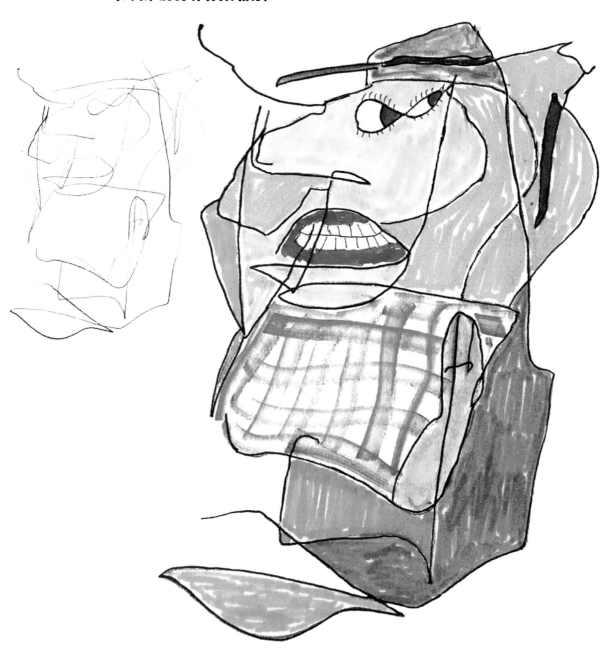

Jeff saw "a pretty girl having a nightmare, gnashing big teeth".

What do you see?

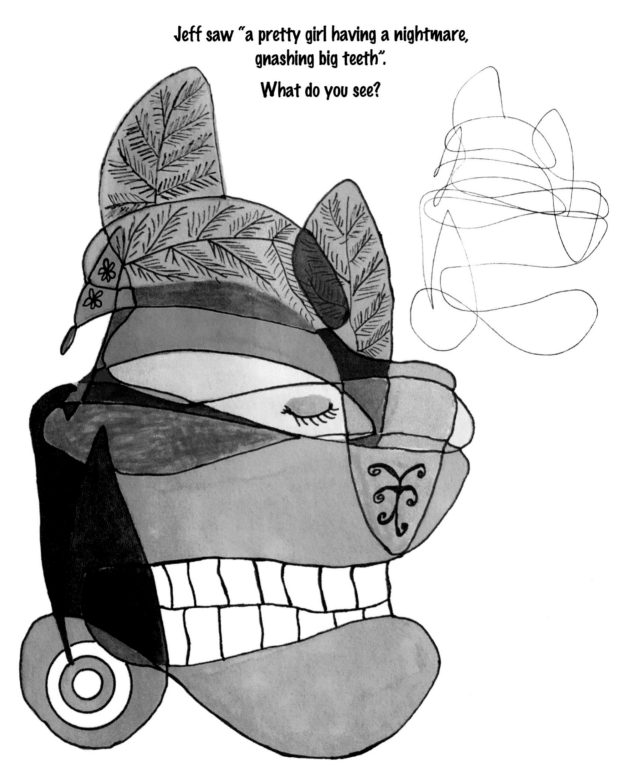

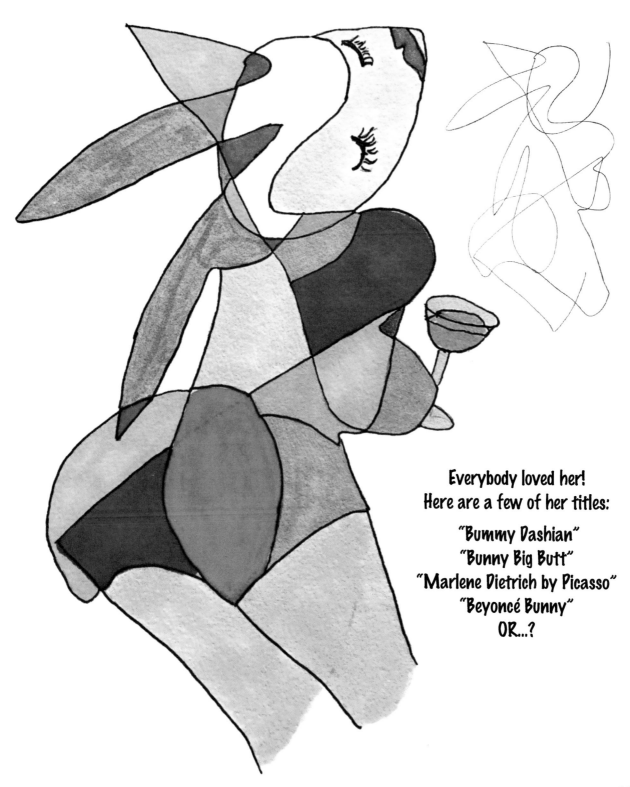

Everybody loved her!
Here are a few of her titles:

"Bummy Dashian"
"Bunny Big Butt"
"Marlene Dietrich by Picasso"
"Beyoncé Bunny"
OR...?

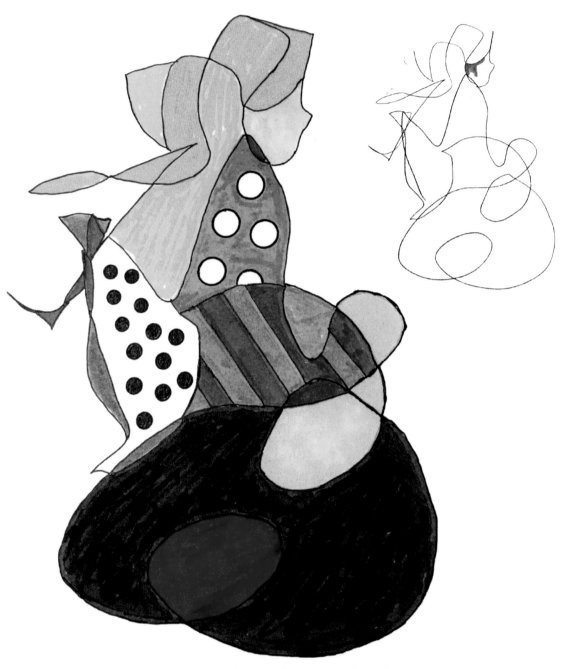

My friend Tom thinks this is an "Amish soccer mom".
John thinks it's "a little Dutch girl".
Is she sitting in a mud puddle?

Or do you see something else here?

One day, I decided to try drawing with my left foot.
It was kinda different, but it worked.
Here's the finished drawing.
Can you find a dog in it?

What else do you see?

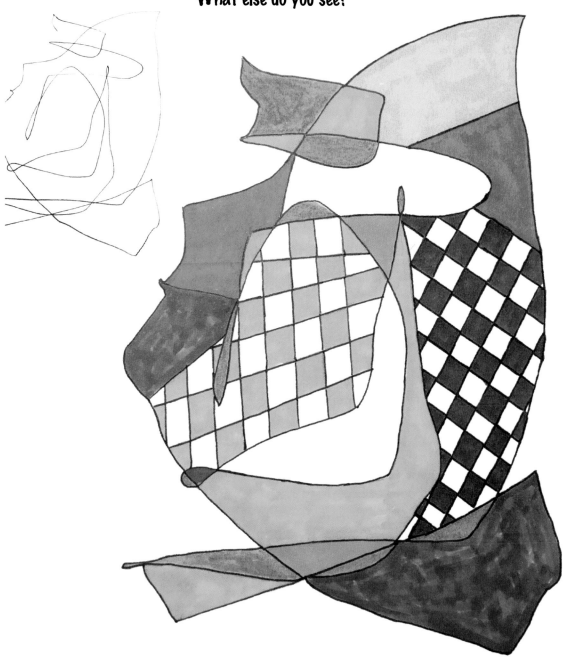

I see a "ZOOM meeting with Fidel".

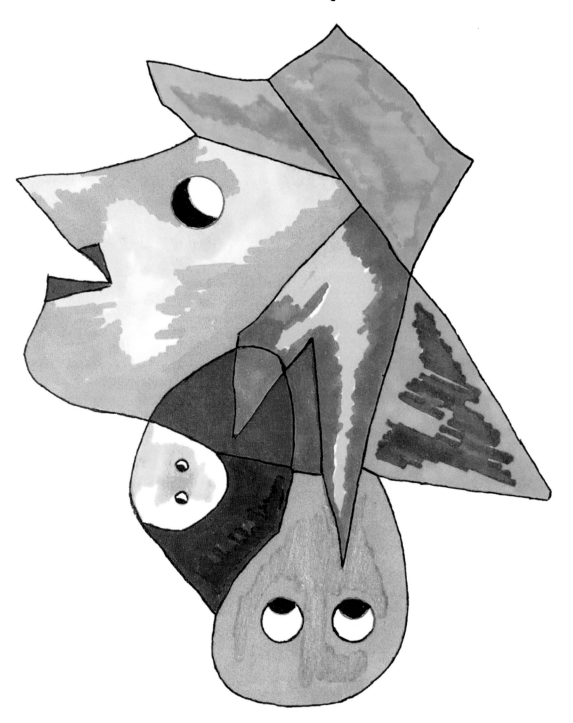

But maybe you see something completely different.
Like what?

"For heaven's sake – ICU!"

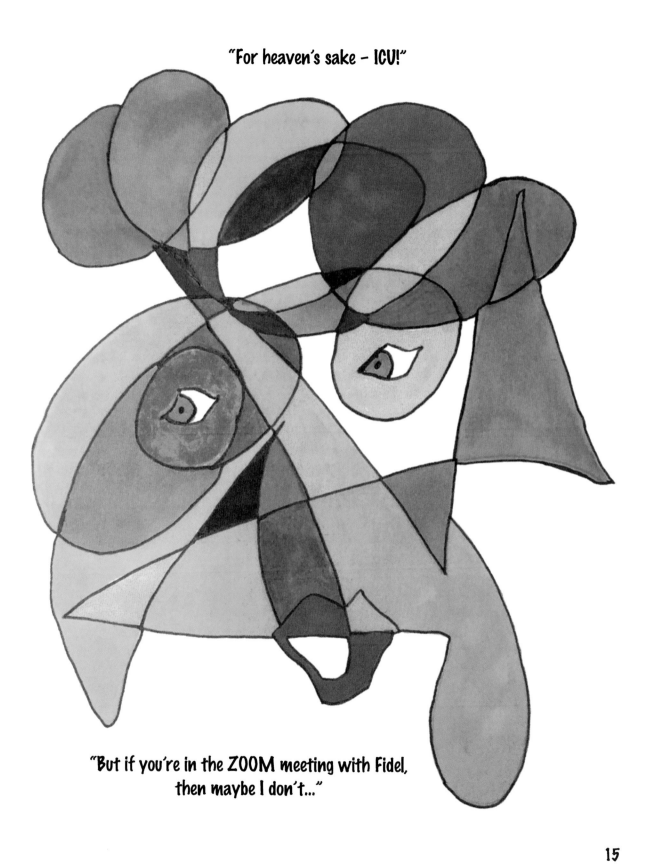

"But if you're in the ZOOM meeting with Fidel,
then maybe I don't..."

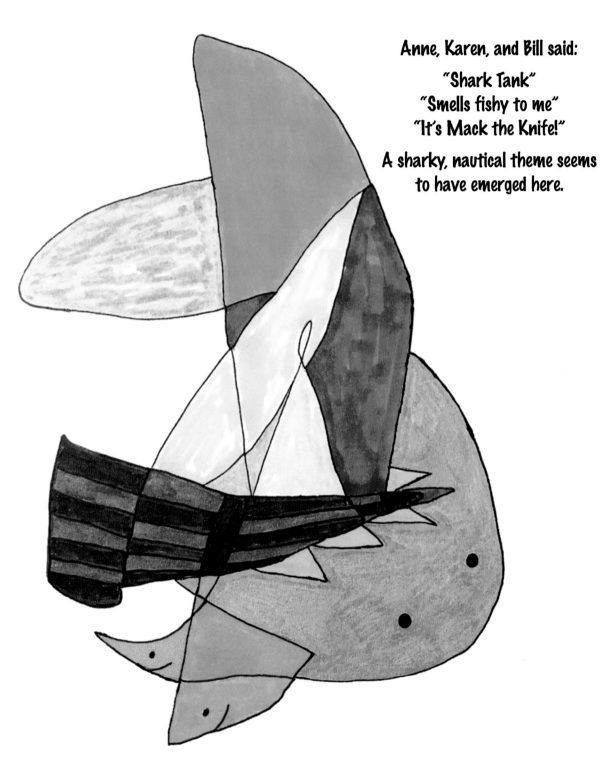

Anne, Karen, and Bill said:

"Shark Tank"
"Smells fishy to me"
"It's Mack the Knife!"

A sharky, nautical theme seems
to have emerged here.

Mary titled it, "Which way is up?"
But you could turn it upside down,
or sideways, and see a few other
things, like a red-eyed dog, or a...?

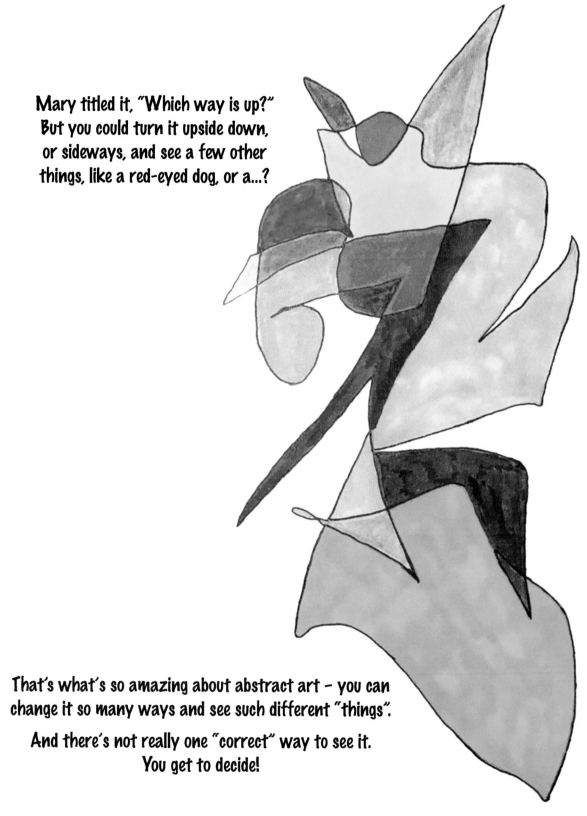

That's what's so amazing about abstract art – you can
change it so many ways and see such different "things".

And there's not really one "correct" way to see it.
You get to decide!

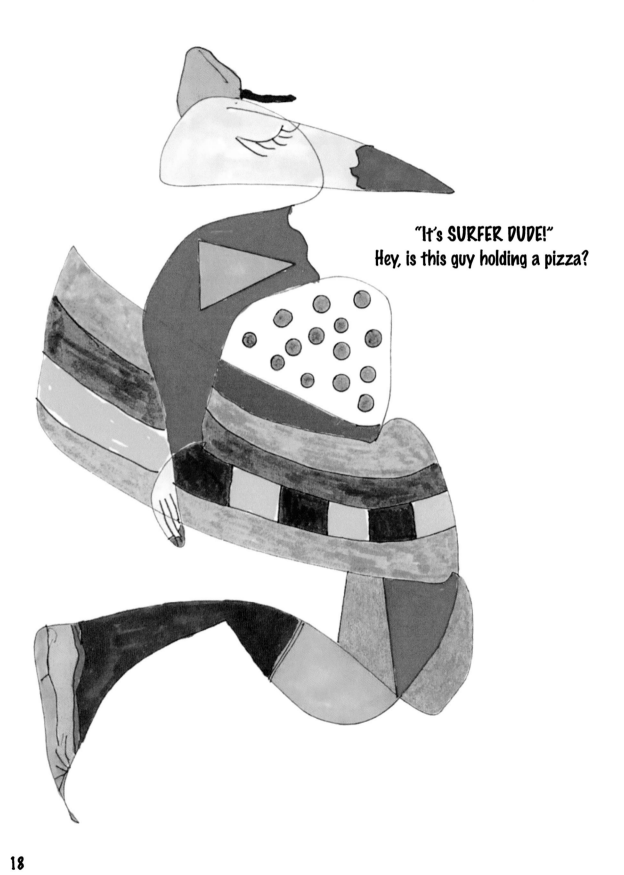

"It's SURFER DUDE!"
Hey, is this guy holding a pizza?

Diane saw "A yummy ice cream cone!"
But Cathy said, "Why, that's Dr. Birx's scarf!"

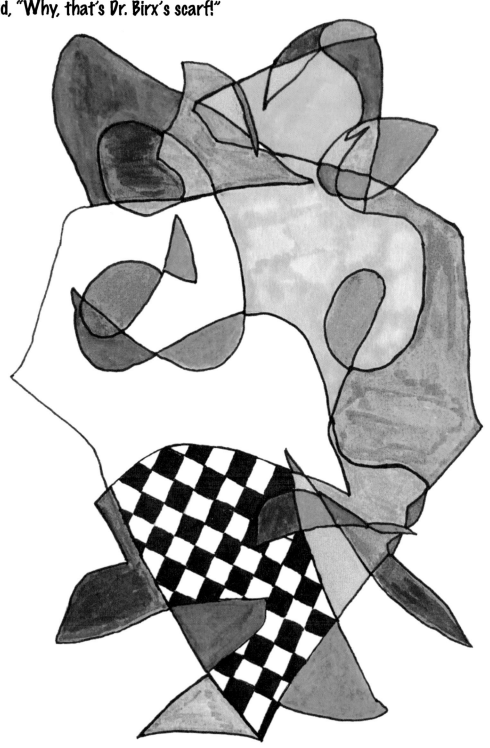

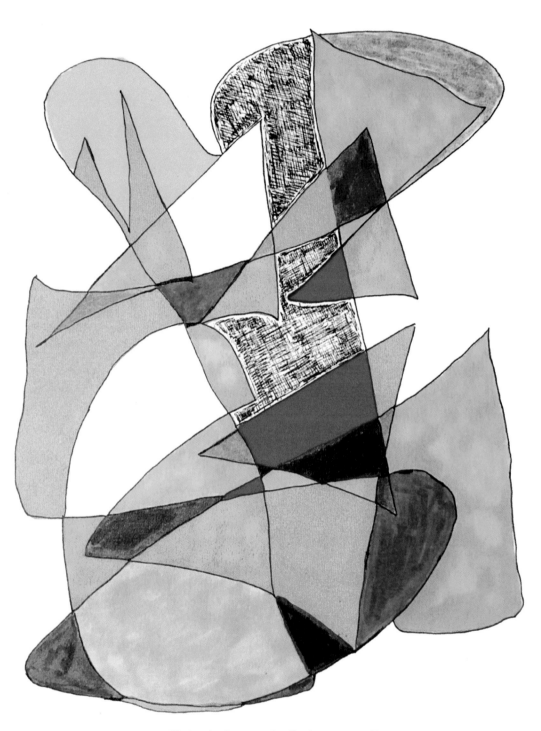

"I don't 'carrot' all about you."
Well, there is a lot of orange – so you see carrots? Maybe.
Bad pun.

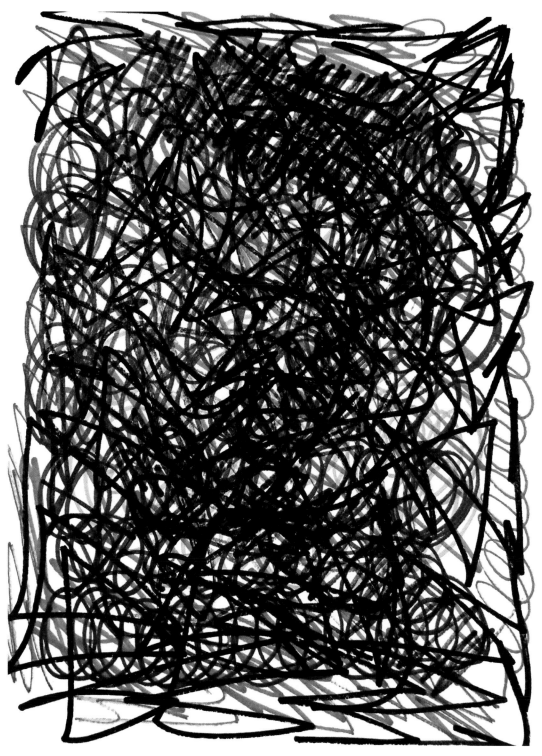

Day 43:
I had a REALLY bad day.

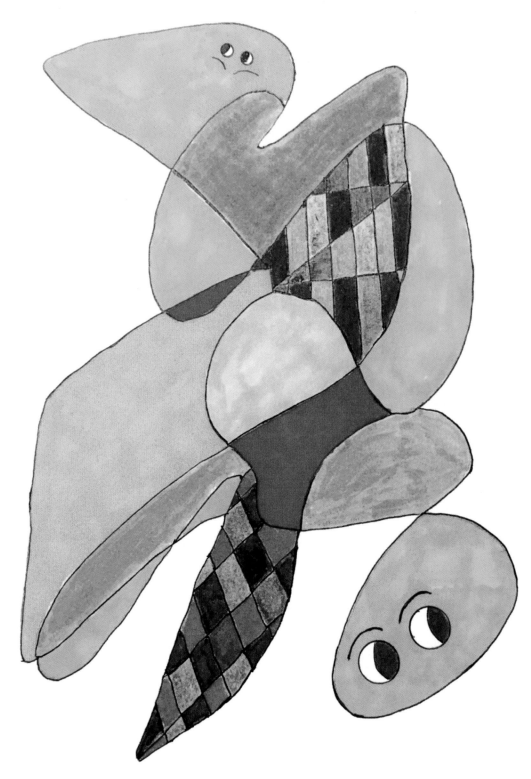

Harold asked shyly, "Shall I wear my Argyles on Friday?"

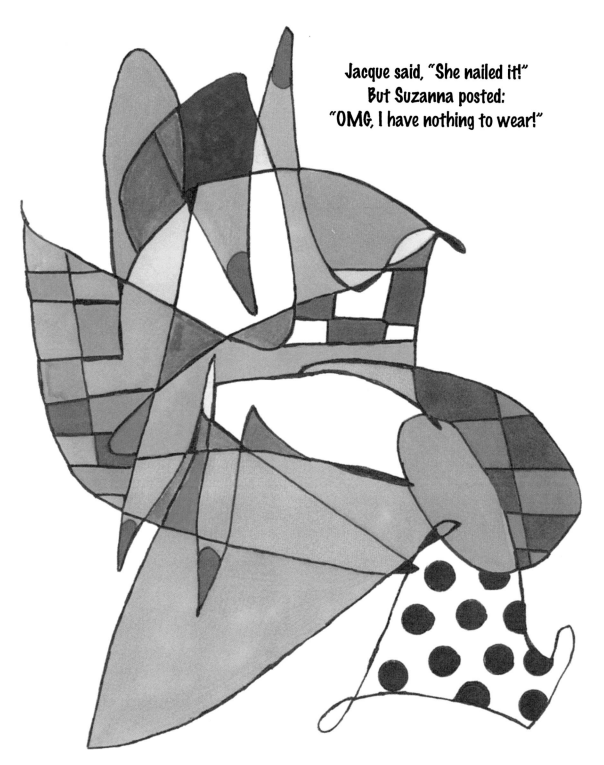

Jacque said, "She nailed it!"
But Suzanna posted:
"OMG, I have nothing to wear!"

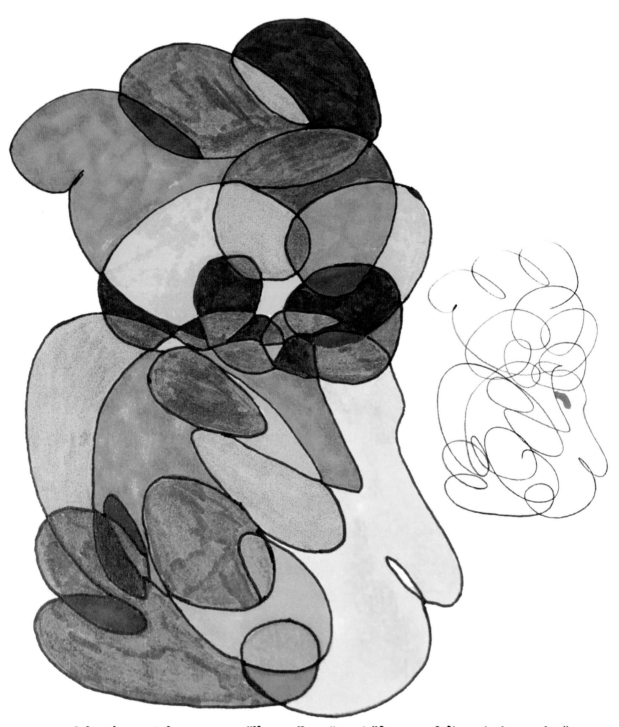

Martha and Amy saw a "Honey Bear", and "Carmen Miranda incognito".
Does anyone remember Carmen Miranda?
Probably not - unless they're over 60!

"I am COVID-19 and I'm coming to get you..."
So stay safe and 6" apart.
(Oops - a typo...But I left it.)

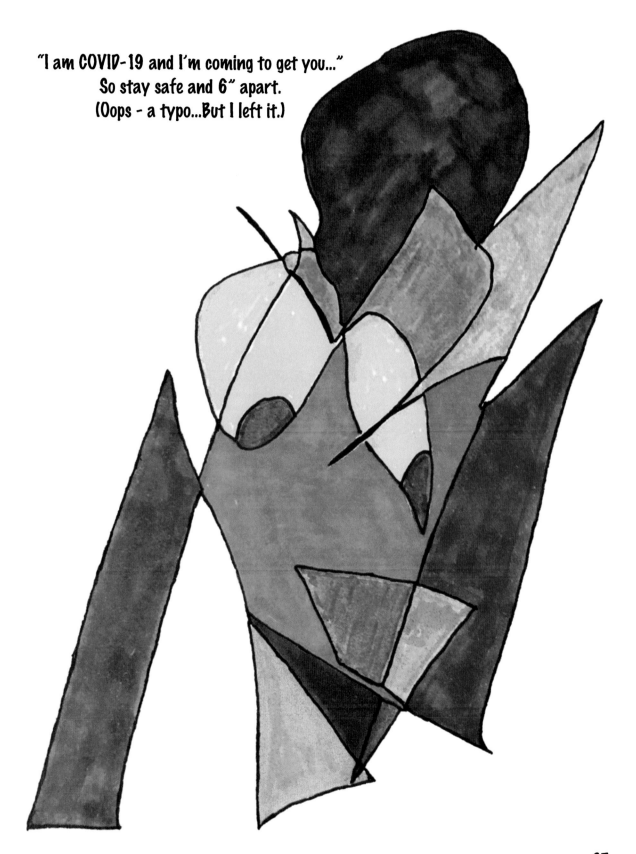

25

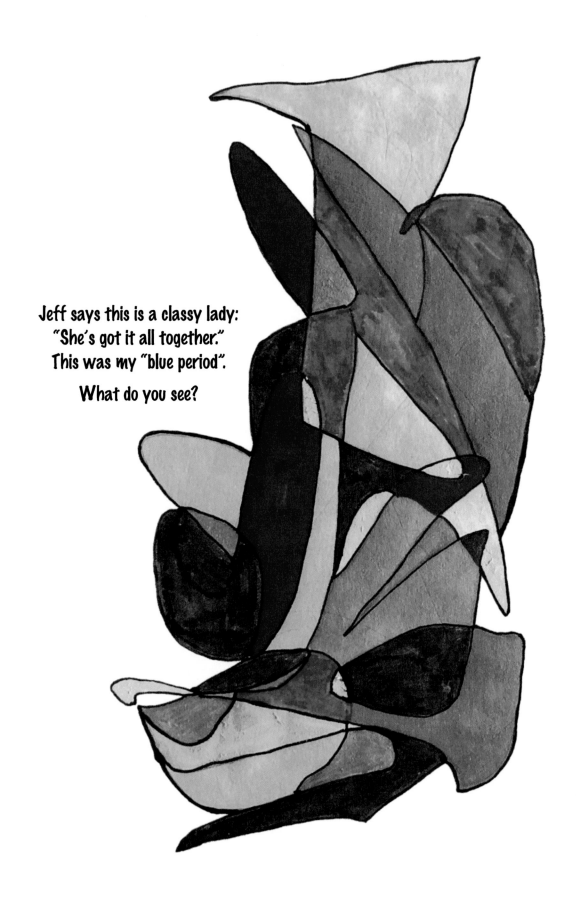

Jeff says this is a classy lady:
"She's got it all together."
This was my "blue period".

What do you see?

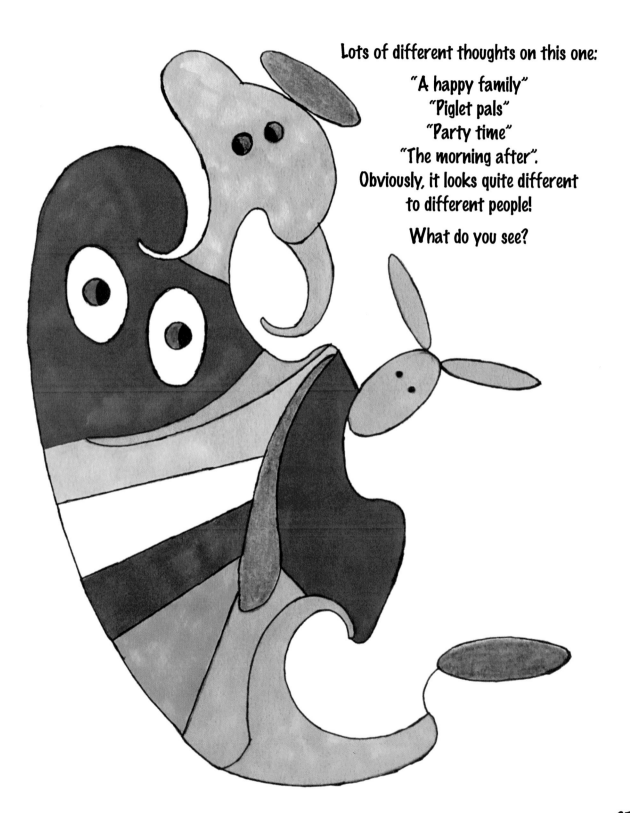

Lots of different thoughts on this one:

"A happy family"
"Piglet pals"
"Party time"
"The morning after".
Obviously, it looks quite different
to different people!

What do you see?

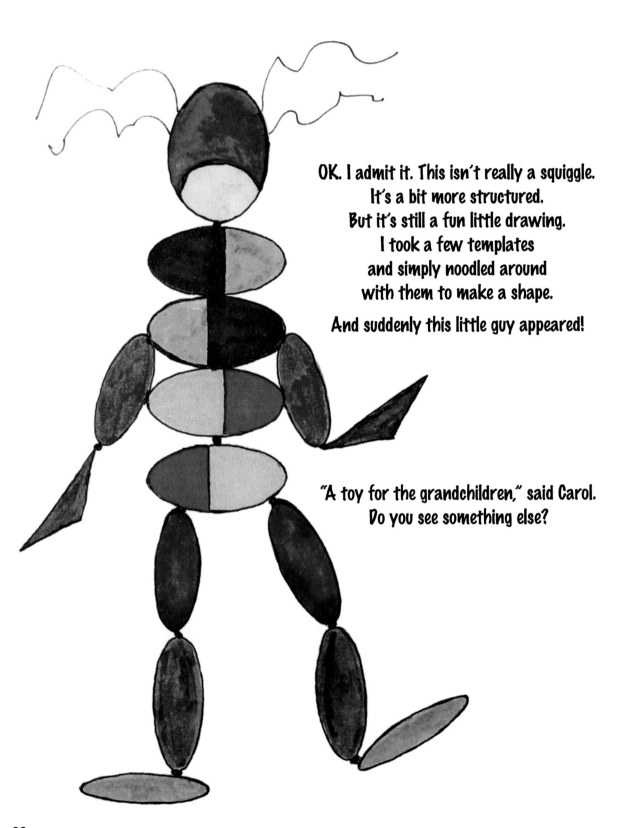

OK. I admit it. This isn't really a squiggle.
It's a bit more structured.
But it's still a fun little drawing.
I took a few templates
and simply noodled around
with them to make a shape.

And suddenly this little guy appeared!

"A toy for the grandchildren," said Carol.
Do you see something else?

This one is pretty structured too, but not really.
Does it make you feel "boxed in"?
Or does it make you feel like "steppin' out"?

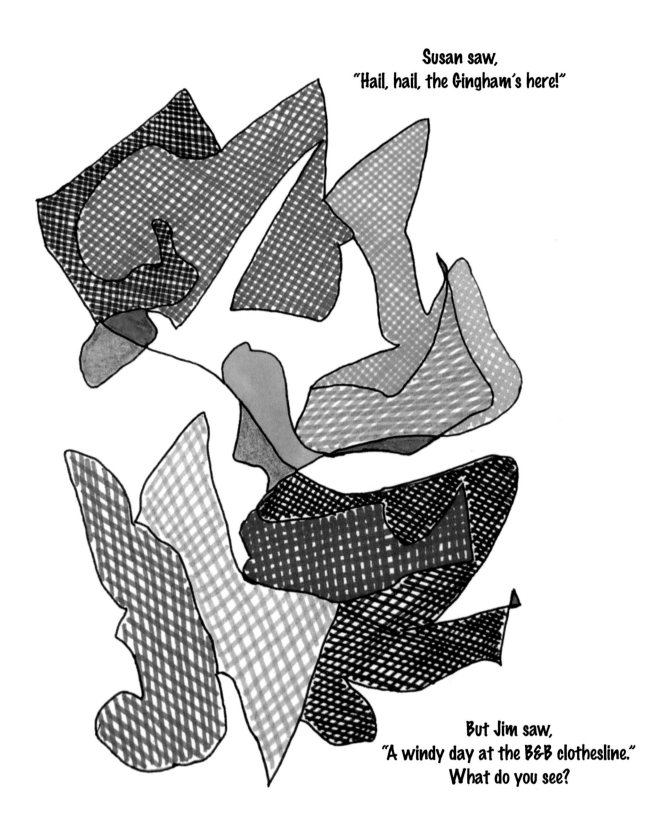

Susan saw,
"Hail, hail, the Gingham's here!"

But Jim saw,
"A windy day at the B&B clothesline."
What do you see?

30

It's gotta be either one of these:
"Here's lookin' at you, kid!"
Or
"Are you going to play THAT again, Sam?"

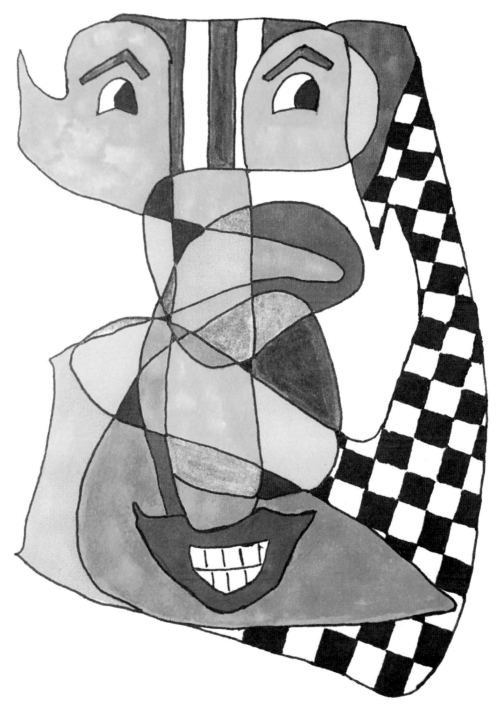

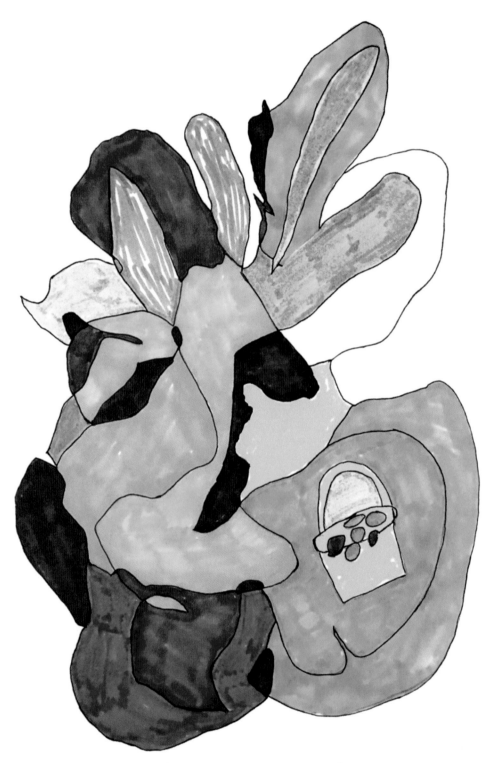

"The Easter Bunny gets pickled."
He's allowed – it's Easter...

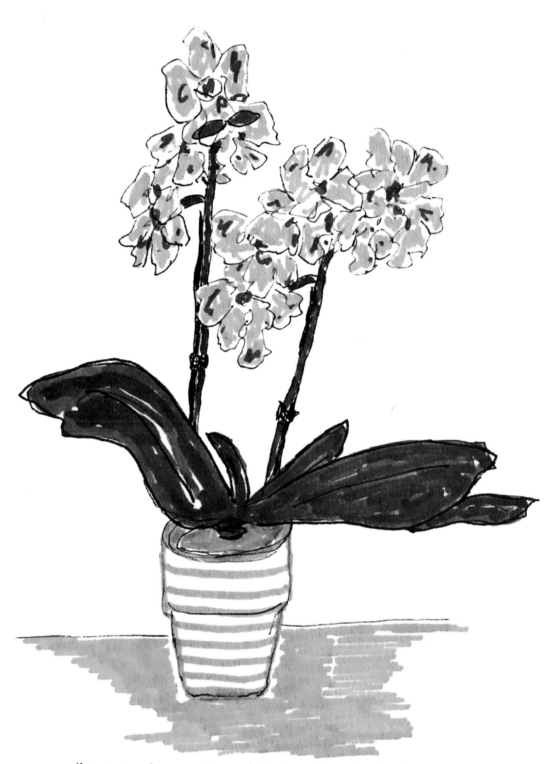

This is simply a pretty orchid plant from Trader Joe's.
(I did get OUT one day!)

Chris said,
"Who EGGED the bunny on?"

Unfortunately, we don't really know. Possibly Mr. McGregor?

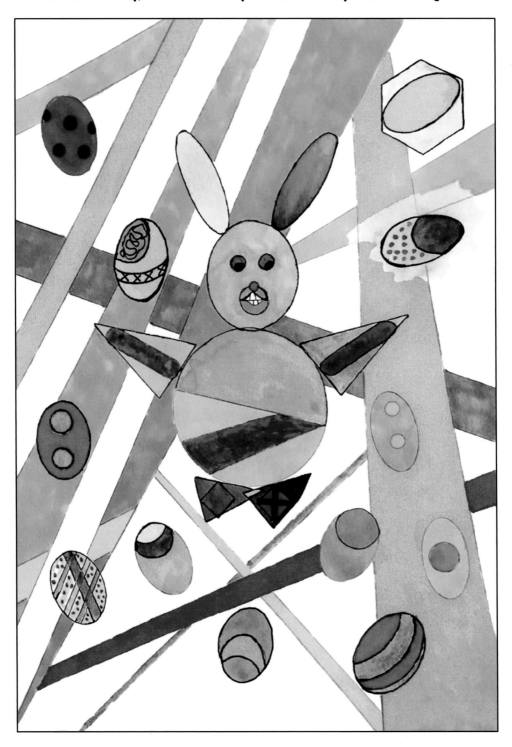

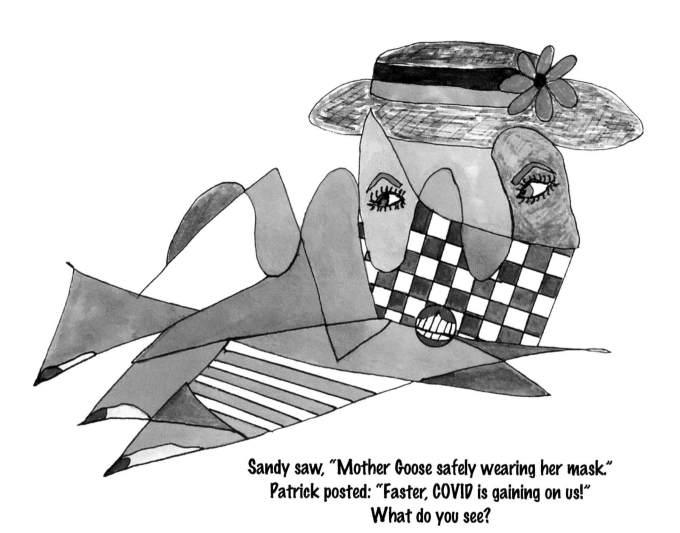

Sandy saw, "Mother Goose safely wearing her mask."
Patrick posted: "Faster, COVID is gaining on us!"
What do you see?

"Barefoot in the Park" –
why, it's Central Park, of course!

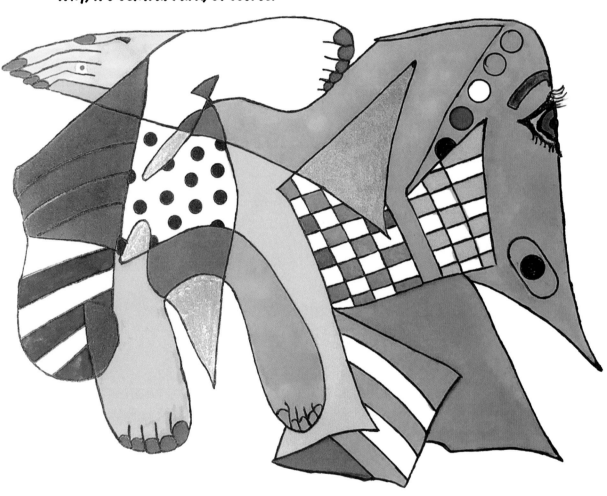

Sally said this was, "A race to the FIN-ish".
Janet saw, "Fisherman's Delight".

And what do you see?

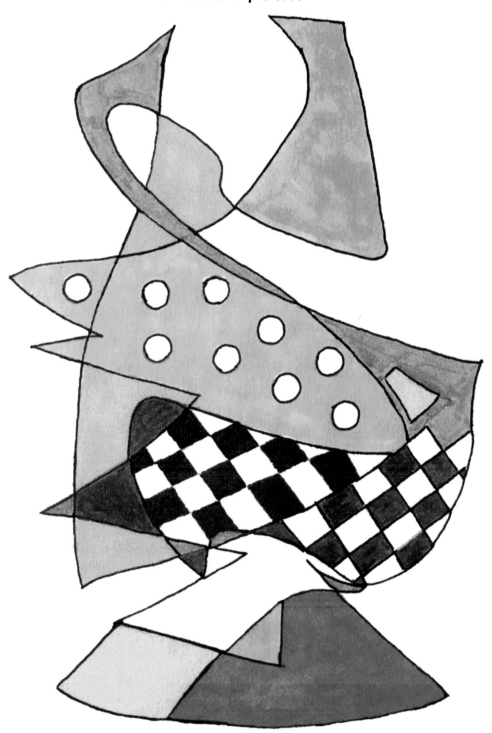

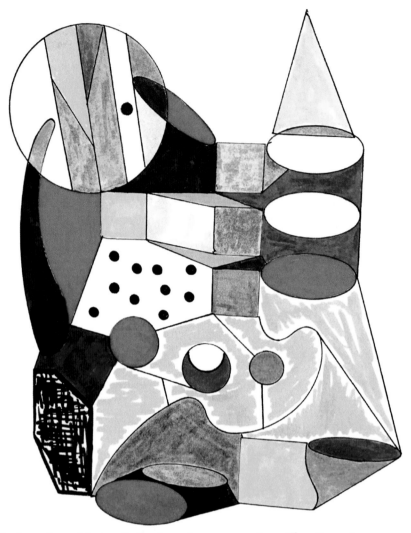

At first, I thought, this book had no deep meaning. The drawings were simply meant to cheer me up. I am hoping they will do the same for you. I want to cheer you up a bit and make you smile during this really crappy time.

But in retrospect, there is a real message here.
When things are really bad, we should all find something to focus on that's important or has meaning and just do it – every day!

Whatever you pick can help you get thru something as horrific as a COVID-19 pandemic. Finding what you enjoy doing every day, even for a short period of time, will refresh your mind, sustain you, and keep you going day after day.

Good luck and stay safe.

Confinement mandated art production,
so I made these squiggle drawings.

Thank you, my friends, for your support,
creativity, kind thoughts,
and witty observations about my art!

We will get through this...

I've included a few pages so you can try making your own squiggles.
Go for it!

41993333R00029